super sweet potato

AuthorHouse™ UK
1663 Liberty Drive
Bloomington, IN 47403 USA
www.authorhouse.co.uk
Phone: 0800 047 8203 (Domestic TFN)
+44 1908 723714 (International)

Published by AuthorHouse 01/06/2020

ISBN: 978-1-7283-9052-9 (sc)
ISBN: 978-1-7283-9051-2 (e)

authorHOUSE®

Super Sweet Potato

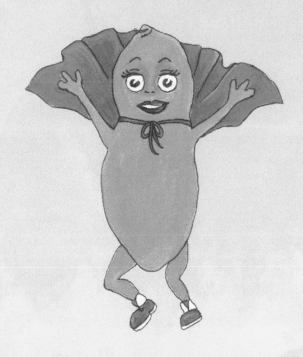

By Kate E Edwards

Illustrated by Sandy Jones

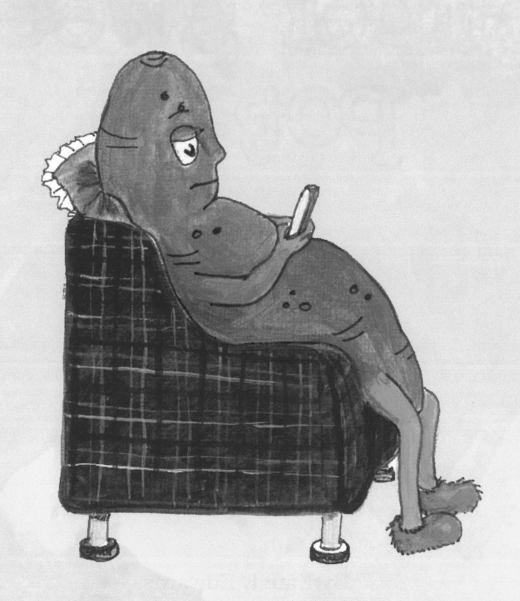

Sweet Potato was feeling low,
She sighed and said "Only one day to go."

It was the day of returning to her club,
Instead of surfing on the hub.

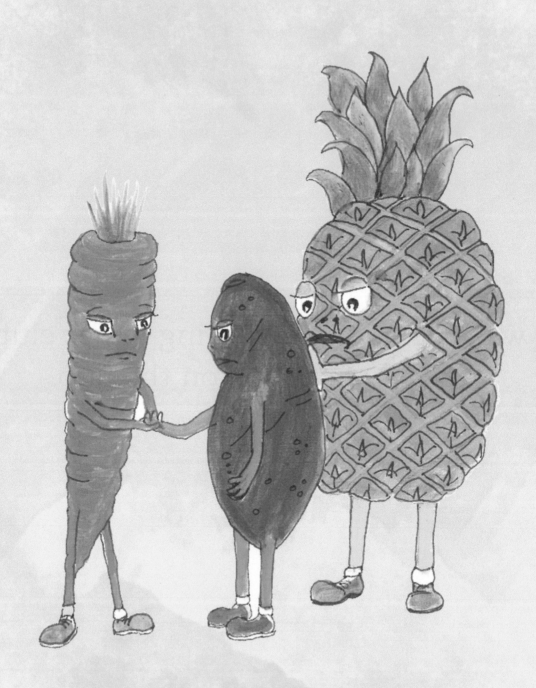

"What's the issue?"
Her friends asked, holding out a tissue.

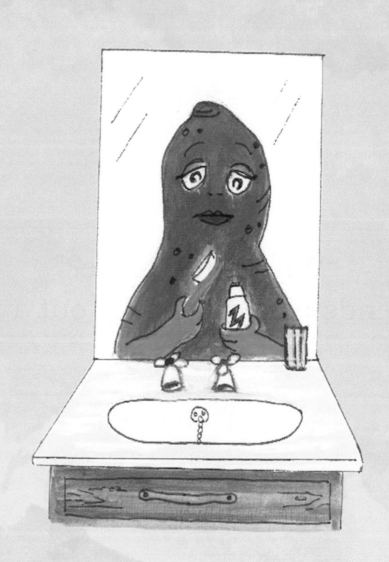

"I'm not feeling right,
Morning, afternoon or night.
It's my lumpy bumpy skin,
Which I'm just not happy living in."

Her friends just couldn't comprehend.
"But you are beautiful - there
is nothing to mend."

They explained to her, "We'll
show you a trick.
We can make something
happen extremely quick."
As fast as ever, they pulled a
speed peeler out of the drawer.
"You won't feel like this anymore."

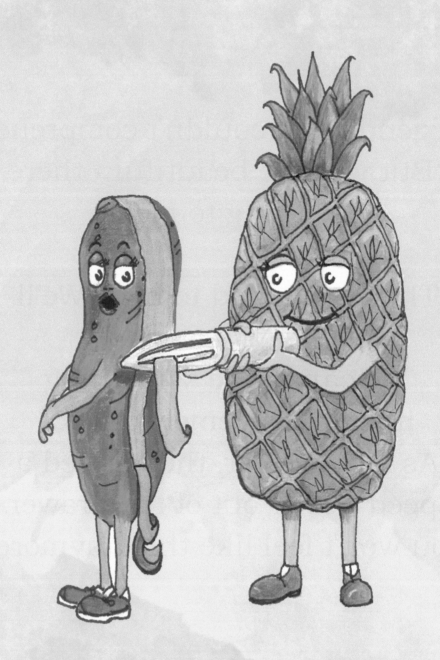

They helped peel a layer off her skin,
And hurled it into the recycling bin.

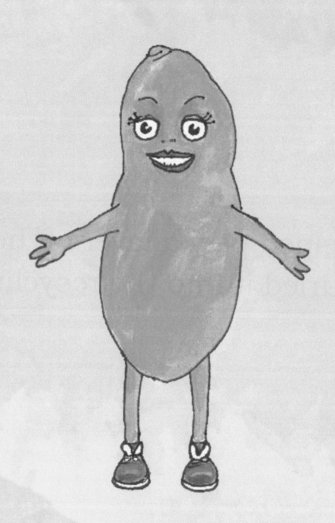

Only to reveal her beauty inside,
Seeing the sunset orange
she felt such pride.
"Look at how amazing you are, it's
what's on the inside that counts.
This is something you will
definitely surmount."

"Beauty is only skin deep,
It's really not a secret to keep.
Practise every day,
And tell yourself you are
wonderful in every way.
You are kind and caring,
And wonderfully daring.
You are fun and charitable,
And extremely reliable.
You are active, loveable and
exceptionally responsible."

"You really don't know your powers,
Dietitians research you for hours.
You are an antioxidant, it means
eating you can prevent diseases,
And so many people this pleases.
You are a superhero or a superfood,
Please believe this and it
will lift your mood."

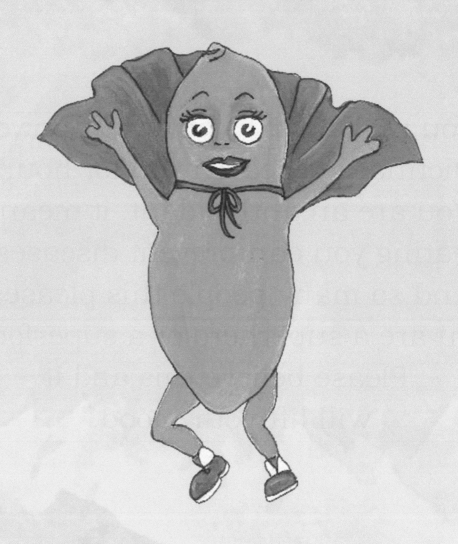

"We'll let you into a little secret, all
your positive beliefs will come true,
But only if you believe in you."
Sweet Potato practised everything
her friends had taught,
Her positive image was well
and truly sought!
Thank you friends for helping me believe,
From now on other positive
words I will conceive."

"Imagine it, believe it and you will receive it." Rhona Byrne, author of The Secret.

Exercises to try

- Look into the mirror and tell yourself you are wonderful in every way.
- Take a look at a sweet potato mindfully. What can you see? Are there any cracks, lumps or bumps? What does it smell like? Can a grown up help you to peel a layer off the skin?
- You could write a list of all of your positive qualities. Why not ask a friend to help you? Can you help a friend write a list of the positive qualities they have?

Printed in the United States
By Bookmasters